T0171333

"I Am"

Jesus of Nazareth

"I Am"

An Illustrational Art of His Name

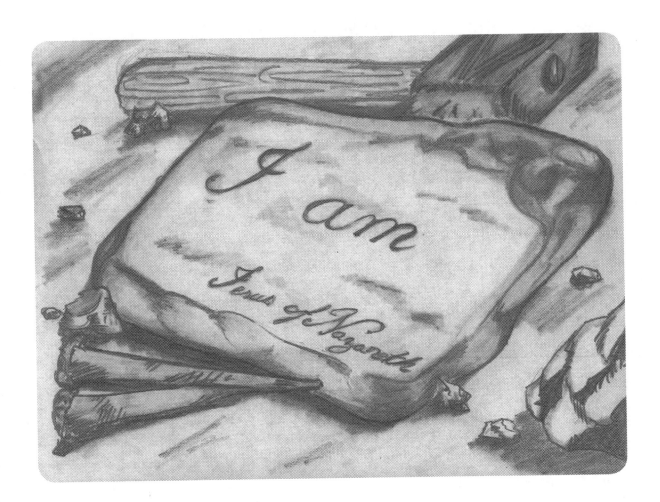

MATTHEW HENSON II

Illustrations by
David McConnehey

WestBow
PRESS
A DIVISION OF THOMAS NELSON

WestBow Press books may be ordered through booksellers or by contacting:

WestBow Press
A Division of Thomas Nelson
1663 Liberty Drive
Bloomington, IN 47403
www.westbowpress.com
1-(866) 928-1240

ISBN: 978-1-4497-7214-7 (e)
ISBN: 978-1-4497-7215-4 (sc)

Library of Congress Control Number: 2012919693

Printed in the United States of America

WestBow Press rev. date: 10/29/2012

Dedicated to Sherril

The love of my life

I love you

INTRODUCTION

Early one morning half asleep/half awake (you know, the point when your sub-conscience and conscience are fully aware of each other?) it finally came to me.

It is my favorite time of the day. The night behind me and the promise of a new day ahead. Nothing wrong, no disappointments have occurred and my heart is open to hearing. I cherish these moments and know that if I'm open and listening, God will speak. And that morning He did and I knew I should carve it.

Some time ago in our small study group. It came out in a discussion that the reason Jesus said "I am" is that he is clamming to be the God of Moses.

> *God said to Moses, "I-AM-WHO-I-AM, Tell the People of Israel, 'I-AM sent me to you.'"*
> *Exodus 3:14 The Message*

There is so much Truth and Goodness wrapped up in this statement. God is saying so much. Can anyone truly say "I am"? We use this phrase often and without thought in our everyday commentary. " I am thirsty." or "I am going to work." No one can make an "I am" claim because of our mortal condition. For if we, who are truly fallen, say that "I am (fill in the blank)" it will be short lived. Because one day our mortality will make its final claim on our existence. God permanently proved to us that He is the only one who can say "I am". He came to us as Jesus from Nazareth. He came in the flesh and made statements of authority and acts of miracles that permanently settled for all time that He is the One who is, and will forever be. He said "I am Life" and "I am the Son Of God" leaving no question as to who He was or who He claimed to be. For those of us who believe we are so glad for this pivotal moment in history. His every word brings Hope and Peace to our dry souls. Finally we have someone who can be Life in us, we can now see because He is Light. Humanity is saved because one of its own is now everything we need. John said it well,

> *There are so many other things Jesus did. If they were all written down, each of them,*
> *one by one, I can't imagine a world big enough to hold such a library of books.*
> *John 21:25 The Message*

I got stuck. How do I bring to light the wonderful brilliance of His Name? How do I illustrate the beautiful message of "I am"? The thought sat in the back of my mind and I pondered it deeply in my heart. God was waiting for the perfect time to let me in on His inspiration.

Without warning it just came to me that morning. It boiled over and the inspiration began to flow from an open spigot with an endless source. I will make a stone like casting to represent "The Stone the builders rejected", and embed in the surfaces the many "I am" statements Jesus said. The simple and plain expression of His Name is quite moving and I hope it moves you closer to Jesus, His true nature, and the invitation to join Him in discovering real Life. When we find ourselves in Him we can truly say, *I am* found in Jesus.

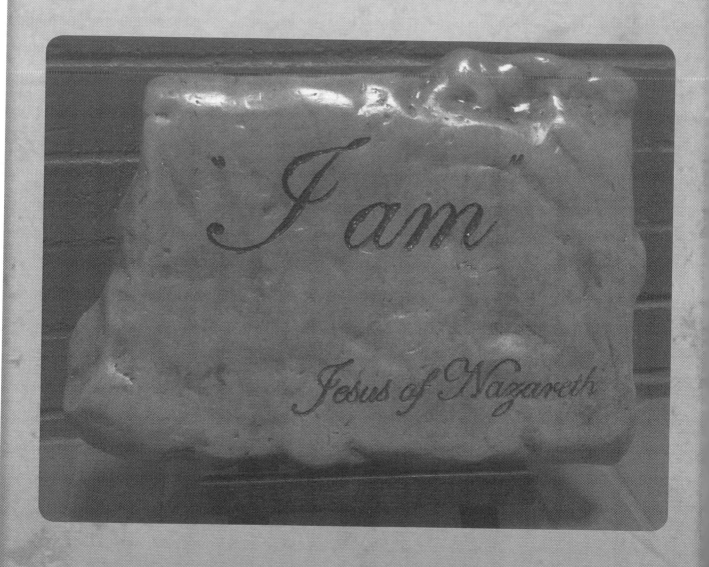

I am

the door

"Do the best you can where you are, and when that is accomplished, God will open a door for you, and a voice will call 'Come up hither into a higher sphere'."

Henry Ward Beetcher
1813 ~ 1887

For those who hear "I am the door" the first thing they think of is, "Behold, I stand at the door and knock". But this is not the same metaphor. This is not the door to our hearts that He is constantly knocking on but rather that He is really the only opening that can satisfy our great need. He alone opens up the once closed passage to the throne of God. No one can come to the Father but though Him.

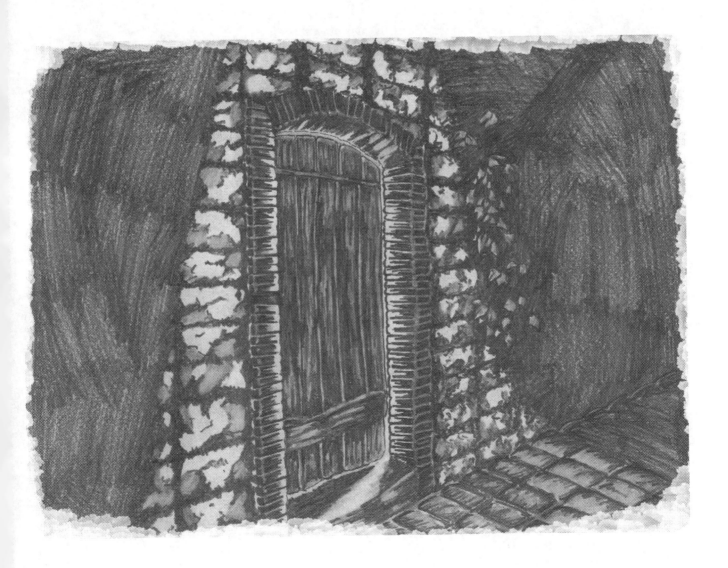

I am

life

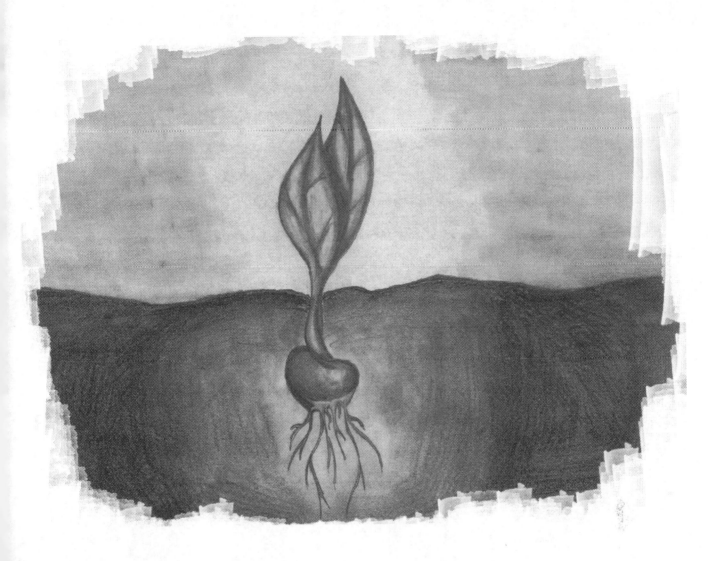

This moves us to realize what He is trying to offer. The one thing we really need and as mere mortals could never attain is Life. We who are born of Adam and Eve are forever trapped in an endless cycle of death and destruction. Every seed can be dormant for years. Ignored, abandoned, and having every appearance of death, but by some unexplained magic, He comes to us and offers us living water and then we come alive.

"A life without a purpose is a languid, drifting thing. Every day we ought to renew our purpose, saying to ourselves: This day let us make a sound beginning, for what we have hitherto done is naught."

Thomas A' Kempis
1380 ~ 1471

I am

the Good

Shepherd

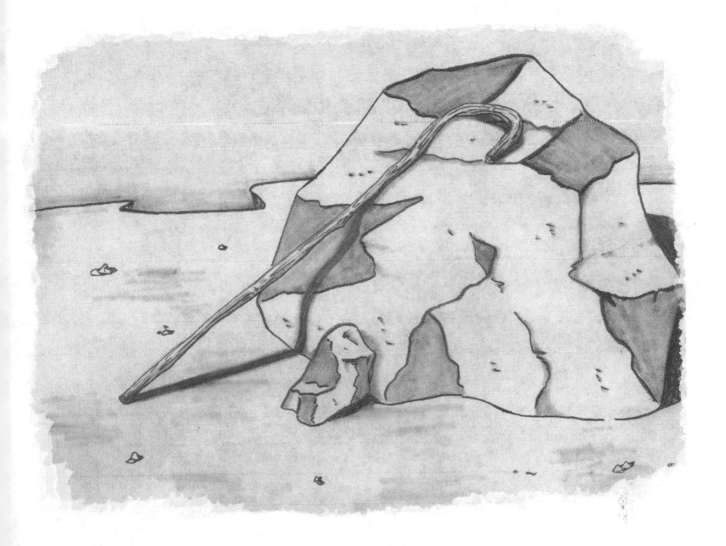

This one brings to mind religious imagery that can cloud the message of Shepherding. You know the languid Christmas scenes of a soft shepherd with no personality. We should look at this from that of the sheep. We are helpless and defenseless in a very dangerous world. We don't have the capacity to overcome or recognize the danger we are in. He is providing for our every need by defending us from our predators and leading us to life giving pastures of green.

"The Shepherd knows what pastures are best for His sheep, and they must not question or doubt, but trustingly follow Him."

H. W. Smith
1827 ~ 1876

I am
the Resurrection

"Our old history ends with the cross; our new history begins with the resurrection."

Watchman Nee
1903 ~ 1972

Too much of Christendom is captured by the imagery of the cross. That is not to say that it is not important. In fact it is one of the most amazing things God did on our behalf. But what is even more amazing is the hope and life that comes from His resurrection. God raised Jesus so all will know His true desire for us, that ALL can come to believe and partake in the eternal life of His Resurrection today.

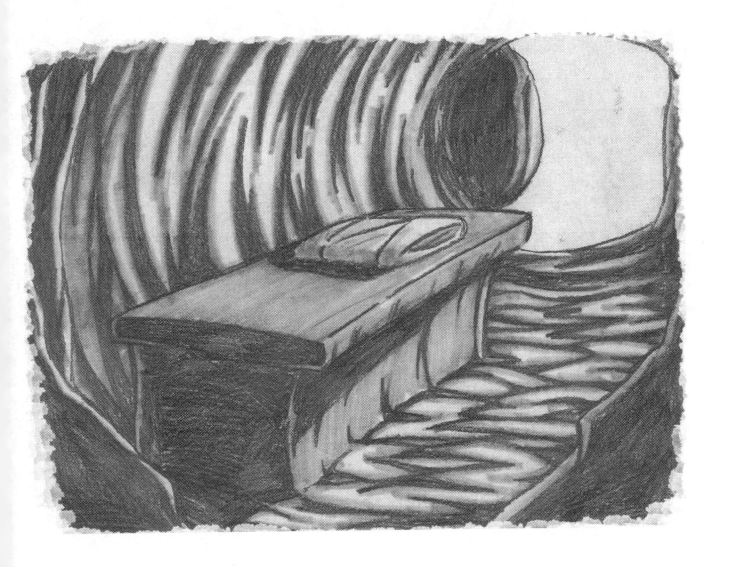

Jam

light

"The issue is now clear. It is between light and darkness and everyone must choose his side."

G. K. Chesterton

Darkness does not exist but it is rather an absence of light. He came into the darkness and everything changed. It exposed us. It reveals our great need. Those that embrace His cleansing Light truly see the wonderful mystery of God.

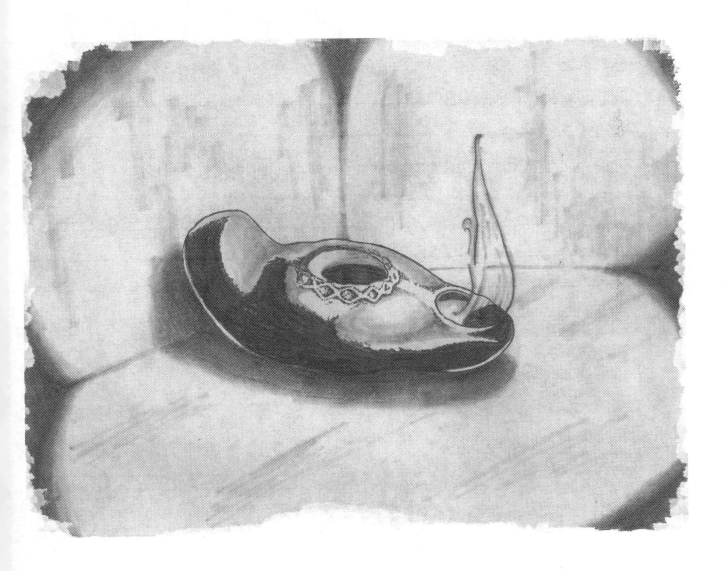

I am

Lord

God gave Jesus all authority in heaven and on earth. He has permanently been placed over all things and it is sealed with His great seal. There are none that stand above Him. There is no place outside of His authority. The day of the Lord has come!

**"Thou hast made us for Thyself, O Lord; and our
heart is restless until it rests in Thee."**

Augustine
354 ~ 430

I am

with you

This promise is so necessary for us to realize within the battlefield of this world. Sometimes His presence alone is all we need. To know that the loving, steady gaze of the King on us, is the most comforting thing we can experience this side of the New Kingdom.

"Christ died for our hearts and the Holy Spirit wants to come and satisfy them."
A. W. Tozer
1897 ~ 1963

I am

the way

> **"Every path that leads to heaven is trodden by willing feet.
> No one is ever driven to paradise."**
>
> *Howard Crosby*
> *1826 ~ 1891*

We find ourselves in the middle of the human story and are uncertain of what to do, act, or what our purpose is. "Which way should I go?" has been asked by everyone. By seeking Him, we find his path for us. Not "What career should I pursue?" or "Who should I marry?" all these things will pass, but seeking His face is all we need now or ever.

I am

the vine

"The branch of the vine does not worry, and toil, and rush here to seek for sunshine, and there to find rain. No; it rests in union and communion with the vine; and at the right time, and in the right way, is the right fruit found on it. Let us so abide in the Lord Jesus."

Hudson Taylor
1832 ~ 1905

Abiding in His ever giving vine of life is absolutely necessary. It is our source of everything. We need it like water and food. Without it we are shriveled and fruitless. We need to abide in Him every moment and with intent. We need do nothing but abide.

I am

not of this world

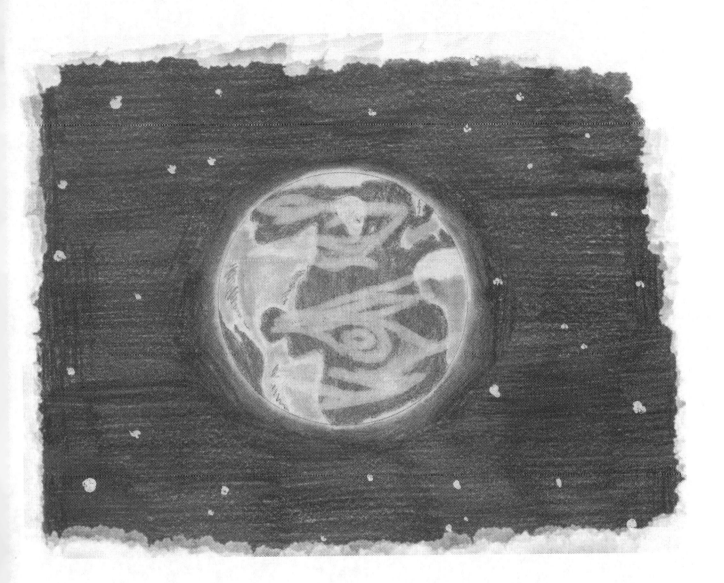

This seems foreign at first, that He is from another planet and is seeking to make peace with us. But really the world as He is addressing it, is a spirit that He does not identify with. The spirit of this world is destructive, decaying, and unforgiving. He does not come from it therefore He is not controlled by it.

"They that love beyond the world cannot be separated by it.
Death cannot kill what never dies."

William Penn
1644 ~ 1718

Jam

the bread

There is a constant and ever need to sustain our existents. We hunger everyday and seek sources to fulfill that need. In the same regard we need Him to sustain our hearts. Our hearts seek for sustenance and it is important that we satisfy that need with Him and Him alone.

"None but God can satisfy the longing of the immortal soul;
as the heart was made for Him, He only can fill it."

Richard Trench
1807 ~ 1886

I am
not alone

The communion between Jesus and His Father is a connection that we only see in the Trinity. They Three ever constant in their purpose with a deep message that we need to tap into. Such a communion with God is possible and normal. Jesus needed His Father and so do we.

"For it is not well for God to be alone."

<div align="right">

G. K. Chesterton
1874 ~ 1936

</div>

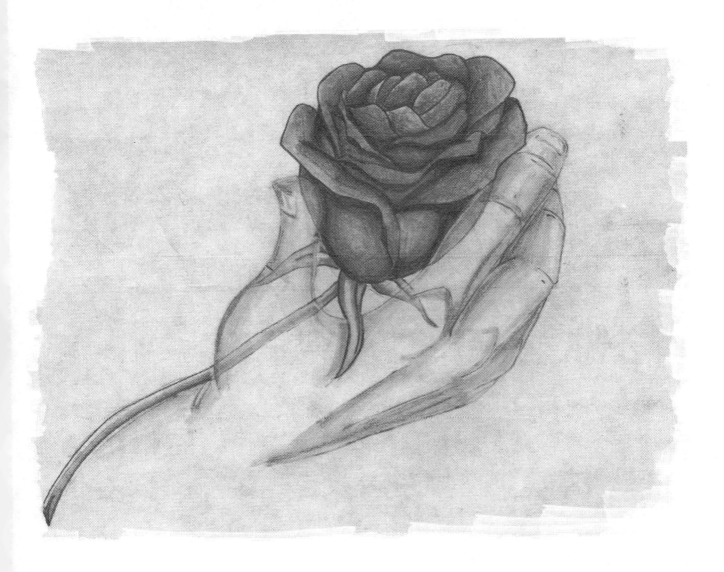

Jam

King

"Christianity is the story of how the rightful king has landed, you might say landed in disguise, and is calling us all to take part in a great campaign in sabotage."

C. S. Lewis
1898 ~ 1963

A majestic King in all His glory and power is the One who is by our side every step of our journey. He was placed at the right hand of Power and presided over it all. Nothing goes unnoticed. Then one glorious day everyone will recognize Him with bended knee and proclaim that He is King of kings.

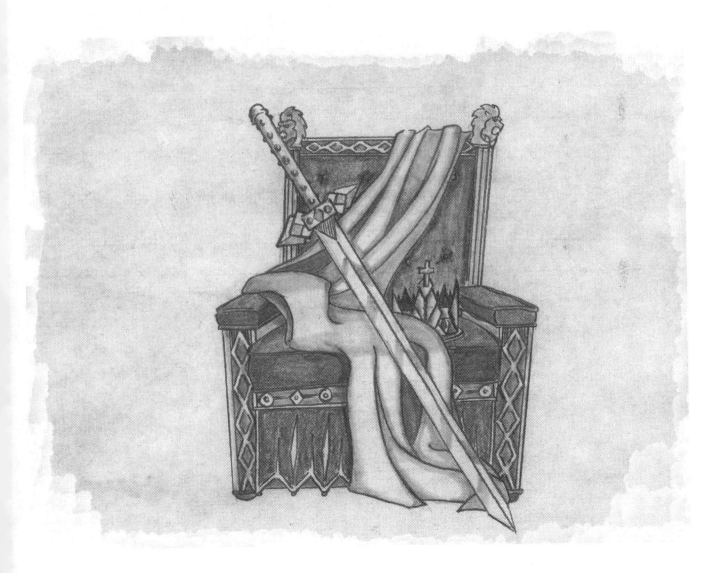

I am

peace

In a world at war and chaos, He provides rest to each of us who believe. Once we were at war with God and now because of Jesus we are at peace. The war between God and mankind was settled at the cross.

"With complete consecration comes perfect peace."

Watchman Nee
1903 ~ 1972

I am

meek

Meekness should not be confused for timidity and weakness but rather should be that of obedience and humility. Like a therapist to the deeply wounded, constantly, and kindly pushing us to work though our pain for our good. He is the Servant of servants.

"A meek spirit gives no trouble willingly to any:
a quiet spirit bears all wrongs without being troubled."

John Wesley
1703 ~ 1791

I am

good

"That which is striking and beautiful is not always good;
but that which is good is always beautiful."

Anne de l Enclos
1620 ~ 1705

With all that scares us about Him it is comforting to know that all of Him is good. That you can trust the great power of the Lion of Judah.

I am

able

"The Son of God became a man to enable men to become sons of God."

C. S. Lewis
1898 ~ 1963

Jesus said, " All things are possible with God." He said this to his disciples when He shared with them the impossibility of overcoming the selfishness of the young rich man. He is able to aid in whatever situation we find ourselves. He has all the tools and He has the ability of the Great Craftsman to set all things as they should be.

I am

Son of God

Jesus is the Son. He is forever the mark of what a Son ought to be. A true and faithful heir to all that is good. And God the Father gave us His one and only. His beloved. If there is anything that shows Gods heart for us it is this most blessed gift.

"Christians believe that Jesus Christ is the son of God because He said so."

C. S. Lewis
1898 ~ 1963

INDEX

Matthew Henson II Grew up in Central Texas living with his grandparents and received a sound upbringing in the Gospel. At the age of 14 he fell in love with the words in the bible. He loves to discover the beautiful message of Hope and Love, and how it teaches who God is and what His intentions are for us.

He has always loved working with his hands. He is a craftsman by trade and has worked on many historic restorations and custom creations and decided to pursue sculpting that reflects his faith. He began Cornerstone Quotations.com to showcase his craftsman skills and to reveal the simple, plain Gospel of Jesus.

He lives with his wife Sherril in Lubbock Texas and they have four daughters who are the light of his eye.

Dave McConnehey grew up in a small town in Indiana. He has been a believer and follower of God from an early age. He has taught within the church as well as seeking out those that can teach him more about the God who loves him, no matter what. He has a love for apologetics and the deeper connections within the bible.

Drawing and design have been a passion of Dave's from early on in life. As with many aspiring artists, he spent much of his childhood with a pencil in one hand and usually a piece of paper in the other. Much of high school was filled with design and art related classes. After high school, David began to freelance his skills to the world. His works have been seen on billboards, CDs, books, and a game box. As his family changed and grew, so did the aim of Dave's life. He is about to complete his Bachelor's degree in Web Design and Multimedia interface, as well as move on to a Masters in Education. He feels God calling him to develop curriculum for home schooled children, like his own, on a multimedia level. God has blessed him in many ways and Dave's desire is only to do God's will and further his kingdom.

Printed in the United States
By Bookmasters